# Poppies & Petals & Things That Fly

Melody Hamby Goss

authorHOUSE®

*AuthorHouse™*
*1663 Liberty Drive*
*Bloomington, IN 47403*
*www.authorhouse.com*
*Phone: 1 (800) 839-8640*

*Published by AuthorHouse 05/10/2018*

*ISBN: 978-1-5462-3904-8 (sc)*
*ISBN: 978-1-5462-3903-1 (e)*

*Print information available on the last page.*

*For Annie*

# Contents

*Birds are the eyes of heaven, and flies are the spies of hell...Suzy Kassem*

*You never walk alone...even the devil is the lord of the flies...Giles Deleuze*

# A Buzzing Fly!

Sleepy-eyed with drink in hand all is right throughout the land,
While swinging 'neath the oaken tree, a buzzing fly
There on me...!

Away I swat my hands in air, that fly a buzzing everywhere,
Falling from my hammock swing, in my hair
That flying thing...!

To my house and through the door, by that fly forevermore,
At last I smile as buzzing wanes...Oh NO!...
He's on my windowpane...!

Crawling there as if to say, "Ha ha I know I've ruined your day",
My house confined this buzzing fly. Somewhere
Somehow I know he'll die...!

On my tables Sunday's news, planning now my murderous ruse,
With fingers rolling round the page, toward
That fly I swat in rage...

Twirling, swirling everywhere through the kitchen up the stair,
Buzzing still he waits me out, round he
Flies all about...

There...! On the door my screen he sits,
through the door I'm throwing fits,
With my paper rolled I shout, and as I turned...he
Locked me out...!

1

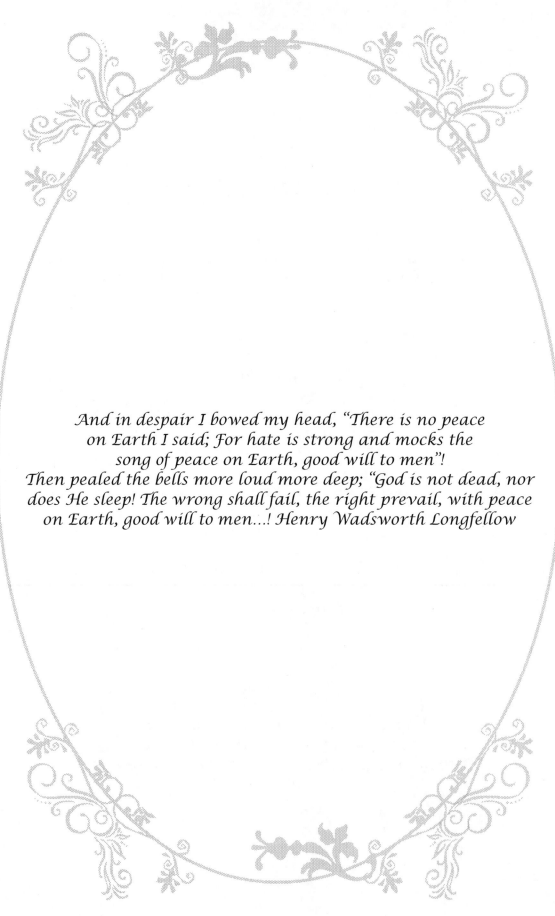

And in despair I bowed my head, "There is no peace
on Earth I said; For hate is strong and mocks the
song of peace on Earth, good will to men"!
Then pealed the bells more loud more deep; "God is not dead, nor
does He sleep! The wrong shall fail, the right prevail, with peace
on Earth, good will to men…! Henry Wadsworth Longfellow

# A Fuzzy Bear Named Teddy

A distant tree is twinkling, guiding Santa's sleigh,
O'er war-torn lands at Christmas,
Where children never play...

Towards the North Star turning, Ol' Santa felt alone,
Hearing angels crying from their
Heaven's home...

Filled bags with toys awaiting some loving children's arms,
Like a fuzzy bear named Teddy, or a little
Dolly's charms...

Round the North Star flying towards a twinkling tree,
Hearken they the angels where peace
Is yet to be...

Reigning in his reindeer o'er sands and cobblestone.
A tiny tree there twinkling, saddened
And alone...

Craters lined the pathways where children once they played,
Singing songs of Christmas in churches...
Now decayed...

By the tree there twinkling ol' Santa sat alone,
Wondering of the children without
Their toys or home...

His toys awaiting children, reaching empty arms,
A fuzzy bear named Teddy, or a little
Dolly's charms...

So, aboard his sleigh this evening, tears on whiskers white,
Turning towards the North Star, again
This Christmas night...

Hearken they the angels where children never play,
With fuzzy bears named Teddy or toys
In Santa's sleigh...

A tribute to Noah Quin Norona, August 18, 1995-March 19, 2018

Rise up and be the light home. You were given the gift
to see the truth. They will have an army of people that
are like them and you are going to feel alone...however,
your family in heaven stands beside you now...
They are your strength and as countless stars...it is
time to let go...your guardian angel L.Alger

# Angels From Afar

Asleep tonight the heaven's weep,
As darkened stars his soul they keep...
Angels they on stairways high,
Rejoicing now, no
Longer cry...

Entwined forever 'neath the stars,
Angels winging from afar...
His journey weary nevermore,
Bound for heaven's
Shining star...

Make the way as angels pass,
No more to wait his soul at last...
Lamps they light at heaven's door,
His journey weary
Nevermore...

No not how the stars now bright,
Standing there his soul tonight...
Bowing heads on heaven's stair,
On bended knees in
Silent prayer...

Together allhis soul they keep,
Asleep tonight, no more to weep...
As they the angels from afar,
Light heaven's stairways
From afar...

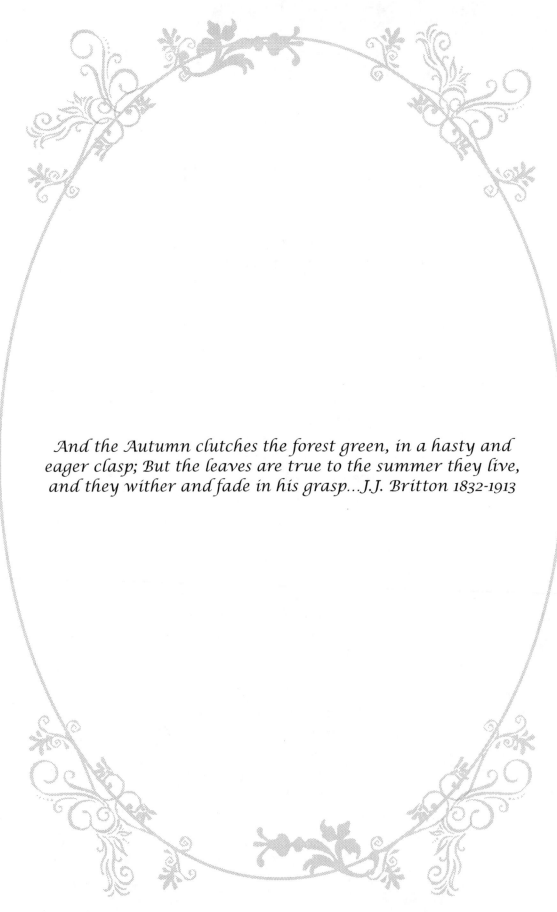

*And the Autumn clutches the forest green, in a hasty and eager clasp; But the leaves are true to the summer they live, and they wither and fade in his grasp...J.J. Britton 1832-1913*

# Asleep the Lilies

Apples round on tender stems, once budded pink and white,
Rose refreshed while growing still, fragrance morning's light...
Asleep the lily's, springtime's host brightened gloomy days,
Midst coming autumn's colored leaves,
Chasing evening's grays...

Once glad and gay wildflowers fade, under august moon,
Where brightly painted daffodils danced once to nature's tune...
As resting geese southward fly 'ore fields of umber brown,
Ducks and drakes on lakeside swim, as
Swans in trumpet sound,

Midst coming autumn's colored leaves onward marches time,
As apples round on tender stems, sway to natures rhyme...
Asleep the lily's, springtime's host awaiting winters flee,
Again the painted daffodils dance yet
"Neath apple tree...

Midst coming autumn's colored leaves, gowned in reddish gold,
Once glad and gay wildflowers fade, too
Nature's promise told...

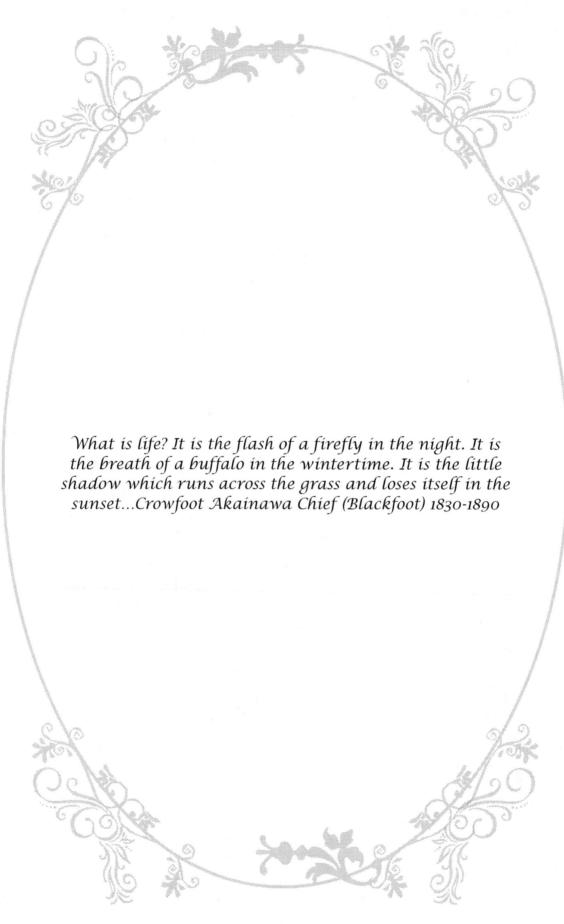

*What is life? It is the flash of a firefly in the night. It is the breath of a buffalo in the wintertime. It is the little shadow which runs across the grass and loses itself in the sunset...Crowfoot Akainawa Chief (Blackfoot) 1830-1890*

# A Summers Farewell Scene

Southward geese are flying, o'er orange tint'd leaves,
Cooling winds are blowing, in autumn's fall-like breeze...
Yellow'd moon of harvest bidding warmth adieu,
Creating twilight's frosty eve's in
Winter-time anew...

Pumpkins fat on tatter'd vines, stalks of corn once green'd,
Yonder cattails nodding, in morning's frosty scene...
Babbling brooks through woodlands, singing nature's tune,
Pines of cone now falling, 'neath a
Yellow'd moon...

Butterflies to Mexico, where snowflakes never go,
Sighing bluebells drowsy, in meadows autumn glow...
Earth's spirit cradles sleepy trees, midst this golden blush,
Woodlands napping happily, waiting
Winter's hush...

Pumpkins fat on tatter'd vines, stalks of corn once green'd,
Yonder cattails nodding, in summer's
Farewell scene...

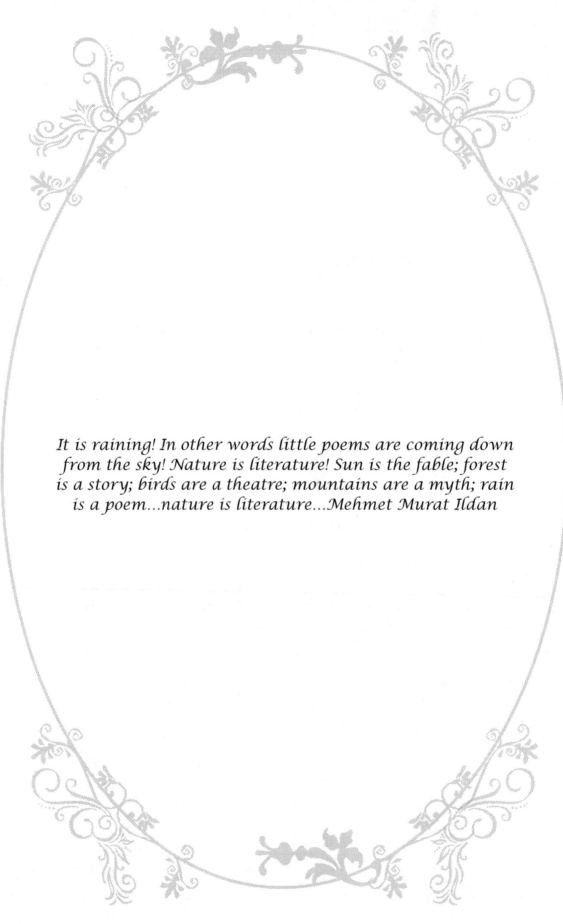

*It is raining! In other words little poems are coming down from the sky! Nature is literature! Sun is the fable; forest is a story; birds are a theatre; mountains are a myth; rain is a poem...nature is literature...Mehmet Murat Ildan*

# A Woodland's Chorus

The eve of twilight's wanderings, 'neath skyways purpl'd-gray,
Waking owls in daylight's dreams from sleepy yesterdays...
Neath forest darkn'd canopy in cadence crickets sing,
With katydids in chorus, while
Flies of butter wing...

As last of shattered sunbeams softly speckle forest floor,
Where mouse's brown in summer hide their winter store...
Leaves scatter'd late from autumn, mock new budding trees,
On twilight's scented wanderings in fragrant
Blowing breeze...

Sad willows weeping quietly with leaves of tiny green,
Neath woodland's darkn'd canopy where little acorns dream...
Humming in the distance their music centuries old,
Bees of honey caroling on beams of
Yellow'd gold...

In tangled vines on forest floor, in cadence crickets sing,
With katydids in chorus while flies
Of butter wing...

*My soul is filled with longing for the secret of the sea,
and the heart of the great ocean sends a thrilling pulse
through me...Henry Wadsworth Longfellow*

# Beneath the Sea

There...behind the weeds of sea,
A turtle swimming, waved to me...
Where whales of gray on surface blow,
Smiling at all their friends
Below...

Fishes silvered seemed to glide,
As dolphins played there midst the tide...
Beneath the sea of turquoise blue,
A turtle waves to me
And you...

There...splashing mermaids tender voiced,
With whales of gray in sea rejoice...
Where little fish in school do play,
In corals pink 'neath
Ocean's spray...

At once a fish of golden hue,
Beneath the sea of turquoise blue...
Upon this turtle hitched a ride,
Away they swam midst
Ocean's tide...

There!...Behind the weeds of sea,
A turtle swimming waved
To me...

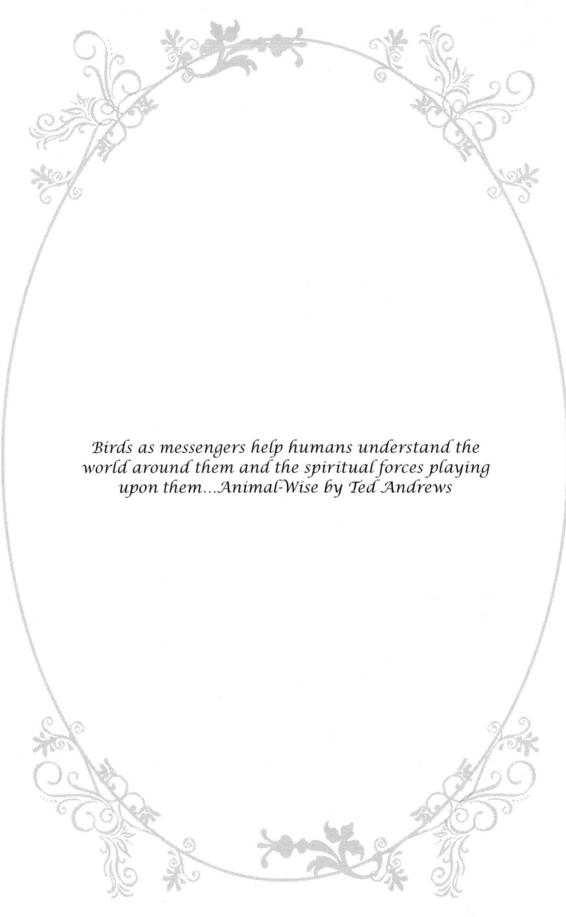

*Birds as messengers help humans understand the world around them and the spiritual forces playing upon them...Animal-Wise by Ted Andrews*

# Bird of Red

Oh bird of red with crested head,
Please your song to hear...
In silence fly when winging nigh,
Again no songs
I fear...

Oh greening trees in swaying breeze,
Please your fragrant scent...
Your sounds of woe in winter's snow,
Away the summer
Went...

Oh mountain high where eagles fly,
Please your secrets keep...
Where spirits prowl and coyotes howl,
In ghostlike haunted
Sleep...

Oh bird of red in trees now dead,
Please a song to hear....
In silence fly where spirits cry,
Again no songs
I fear...

*The mountains I become a part of it, the herbs, the fir tree, I become a part of it. The morning mist, the clouds, the gathering waters, I become a part of it. The wilderness, the dewdrops, the pollen...I become a part of it...Navajo Chant*

## Butterfly Kisses

A butterfly is but a kiss, from nature to me,
They dance and prance in color for...
All the world to see...

Around the meadow flying by the river flows,
Appearing as if magic, humming...
Where it goes...

Floating to their music a chorus in the sky,
They dance and prance in color as they
Did in days gone by...

A kiss is like a butterfly on a summer's breeze,
Among the flowers playing, and gliding...
Through the trees...

In beauty they remind us, each fluttered tiny wing,
They're the kiss of Mother Nature, in the...
Chorus where they sing...

...so I return to the ocean depths where swimming creatures fly. For there I can soar with the whales and fish that daily touch the sky...Richelle E. Goodrich

# By Ocean Dunes

On coral tinted shores of sea,
Voiceless words from shells to me...
Centuries still'd forever sigh,
By ocean dunes that
Never cry...

Enchanted reefs of coral bare,
A sunless crypt as mermaid's lair...
Where herons wade and egrets fly,
By ocean dunes that
Never cry...

Voiceless words as trade winds blow,
Of tales untold the story goes...
Yo-ho-ho old pirates die,
By ocean dunes that
Never cry...

Cypress trees in ghostly calm,
Wink knowingly to greening palm...
Awaiting death 'neath bluing sky,
By ocean dunes that
Never cry...

Voiceless words from shells to me,
On coral-tinted shores
Of sea...

*I want to paint the way a bird sings...Claude Monet*

# Chickadees & Sparrows

Summer's in the offing, gone is winter's snow,
Silent springtime saunters as warming breezes blow...
Chickadees and sparrows chirping in the trees,
As tiny buds yet sleeping, awaiting
Honey'd bees...

Mocking snowy winters, in graying mountains vale,
Dreaming dreams of summer, in budding flowr'd dales...
Chickadees and sparrows, in woodlands tender green,
Wake lavender and poppies from sleepy
Wintry dreams...

Blooming yellow daffodils, by pansies purple-blue,
Mocking snows of winter, in springtime's early dew...
As chickadees and sparrows chase the honey'd bee,
As tiny buds lie sleeping in fragrant
Myrtle trees...

Yawning springtime wakens, under skyways blue,
As chickadees and sparrows, bid
Wintertime adieu...

*Happy Christmas to all and to all a goodnight*

# Christmas Mouse Hunt

Through the midnight winking 'neath lights on tree a'twinkling,
With whiskers twitching slightly....AWAY!
You wake me nightly...

No py for rent you give me, your food and board are not free,
So upon this midnight dreary, I devise your
Death most clearly...

"Neath lights on trees a'twinkling, by gifts you hide a'winking,
T'was then I wondered slightly, your trap with
Cheese smeared lightly...

Upon the midnight dreary, your death I giggle clearly,
Adieu my foe deceiving as I ponder
Not my grieving...

Awake this Christmas morning on eve all night a'snoring,
No eyes to me a'winking 'neath lights
On tree a'twinkling...

Upon my lips beguiling my head I lay while smiling,
Eyes half closed while resting...AGAIN!
I hear you nesting...

With whiskers twitching slightly, lips smeared with cheese so lightly,
Amid again our meeting, you whisper...
"Season's Greeting"

*Hold fast to dreams, for if dreams die...life is a broken-winged bird that cannot fly...Langston Hughs*

# "Courage" Cries the Dewdrop

The dewdrop sadly shimmers in twilight's waning haze,
"Courage" cries the dewdrop, waiting
Dawning's rays...

The tiny leaf of willow weeps on lonely twig of tree,
Nevermore to feel the sunlight, or
Humming bumblebee...

The rainbow's fading colors alter tinted clouds once gray,
"Courage" cries the rainbow o'er meadows
Green'd and gay...

The hibiscus blooms in glory knowing not their fated stay,
Reigns bright upon their moorings, at last
On ground they lay...

That phantom somber sunset pleads to twilight's haze,
"Courage" pleads the sunset, lighting stars to
Chase the grays...

"Courage" cries the dewdrop, in twilight's coming haze,
Each dawning time I shimmer while
Waiting morning's rays...

"Courage" cries the 'morrow, let sleeping dreamers lie,
Sleep yet unto the morning for
Tomorrow never dies...

*When weeds go to heaven, I suppose they*
*will be flowers...L.M. Montgomery}*
*{They're just weeds love; they don't belong anywhere...that doesn't*
*seem very nice, everything belongs somewhere...Kathryn Hughs*

# Coy Buds on Stems of Roses

Coy buds on stems of roses in daylight disguised,
By wildly growing flowers unnamed and left to die...
Be not coy sweet rosebuds fair and fragrant be,
Abiding not the flowers wildly
Growing free...

Whose scent forever lingers your blush so much desired,
Shun not the others beauty common yet admired...
Unfurl your fragrant petals wondrous sweet and fair,
Coy buds on stems of roses scenting
Gardens everywhere...

Kept not by gardens tended, unnamed and left to die...
Wildly growing flowers unseen by many eyes...
Sweet as roses blooming common they may be,
Abiding not the gardens wildly
Growing free...

It matters not the beauty whether sweet or fair,
Or flowers growing wildly, in gardens everywhere...
Disguised in silence knowing scenting lawn and lea,
By buds on stems of roses common
They may be...

The wall is silent, the grass is sleep, tall trees of peace their vigil keep, and the Fairy of Dreams with moth-wings furled...plays soft on her flute to the drowsy world...Ida Rentoul Outhwaite

The realm of fairy is a strange shadow land, lying just beyond the fields we know...Author Unknown}

# Fairies of the Dawn

Streaming beams of golden light, on my windowpane,
Winged fairies tiny dancing bidding twilight's wane...
As silent morning saunters upon my sleepy lawn,
There! Shadowed dewy footprints from
Fairies of the dawn...

Wings of silver'd starlight o'er heaven seem to glide,
By my window dancing on golden beams they hide...
In sleepy lawns and meadows leaving prints of dew,
As waning twilight's promise welcomes
Skyways blue...

Oh tiny fairies of the dawn hear your tearful sigh,
While through my window peeking silently you cry...
Leaving dewy footprints before your daylight flee,
On wings of silver starlight while
Reaching out to me...

Fading footprints tiny upon the waking dawn,
Through once my window watching
Were fairies on my lawn...

*If I had a flower for every time I thought of you...I would walk through my garden forever...Alfred Tennyson*

# Forevermore

Like the sea without a shore, or forest without the trees,
Like stars without their moon, you're my honey
Without the bees...

You're the honor to a dawn, the mystery to my day,
You're a bloom upon the rose, you're my sun
When skies are gray...

You're the window to my soul, my tune without a song,
You're the answer to my prayers, my right
Without a wrong...

Like a candle in the dark, or light to distant shores,
You're the wind beneath my wings, and I
Wish you love...forevermore...

*I may not be a butterfly so none will notice me...but God made me a dragonfly, so a dragonfly I'll be...Melody Hamby Goss*

*The dragonfly brings dreams to reality, fantasy to hearts and is the messenger of wisdom and enlightenment from other realms...*

# Flight on Tapestry

Around their flight on tapestry, with wings of turquoise blue,
Bare is the night still hidden where cattails
Tiny grew...

Glow-worms bid the evenings in their dell of dew,
As dancing maidens sweetly, beckon
Lovers true...

Embracing sad the sunset, iris purple-gowned,
Perfumes yet the valley with
Dragonflies around...

On grasses twinkled silver, only they, the maidens knew,
Glow-worms bid the evenings where
They, the maidens flew...

Around their flight on tapestry with wings of turquoise blue,
These sweetly dancing maidens kissed they
Their dragons true...

Each evening sad the sunset embracing dragonflies,
While gowned in iris purple dance
Maidens in disguise...

*But he who dares not grasp the thorn should
never crave the rose...Anne Bronte*

*There is a certain part of all of us that lives outside time.
Perhaps we become aware of our age only at exceptional
moments and most of the time we are ageless...Milan Kundera*

# Fragrant Yet the Rose

But he who dares not grasp the thorn should
never crave the rose...Anne Bronte

So fierce the winds as a tempest blows,
Where shadows dance 'neath springs new rose.
Soft the petals to earth they cry,
Away to fade where roses
Die...

Hide sweet blooms yet not red,
As fierce the winds round garden's bed...
When a blowing tempest caring not,
Pluck soft the petals time
Forgot...

Stained red the tips when roses die,
Away to fade on earth they lie...
Specter-thin they fragrant yet,
As fierce the winds sweet
Blooms forget...

Beauty once in youthful guise,
Cry no more when roses die...
Away the winds time forgot,
As a tempest blows I'm
Fearing not...

*Mistletoe possesses mystical powers, by hanging it in the home it will ward off evil spirits. It is a sign of love and friendship. A Norse mythology where the custom of kissing under the mistletoe comes from. Being green year round and surviving harsh winter winds.*

# Green the Mistletoe

Past meadows white of winter,
O'er streams whose waters flow...
Limbs bare of summer flowers,
Grows green the
Mistletoe...

These fairy-lands at Christmas,
In days long gone before...
Amid the sleeping flowers,
A kiss from ancient
Lore...

Tread slowly o'er the pathway,
Where tender leaves shall grow...
Past meadows white of winter,
Grows green the
Mistletoe...

Gather slowly leaves so tender,
Where winds of winter blow...
'Neath their flowers kissing,
Grows green the
Mistletoe...

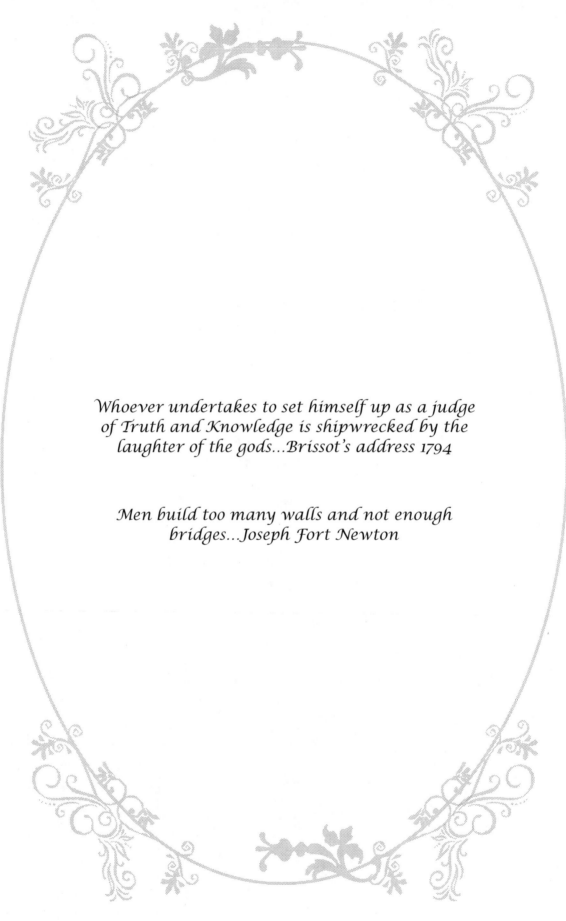

*Whoever undertakes to set himself up as a judge of Truth and Knowledge is shipwrecked by the laughter of the gods...Brissot's address 1794*

*Men build too many walls and not enough bridges...Joseph Fort Newton*

# Hello My Friend I See You

Sick at heart I shudder where hate so much is found,
Like a blight o'er spirit shrouded hope
Lies bound...

Passed I today another while casting eyes away,
Stealing sunshine's shadow, in darkness
Ever gray...

My friend, "Hello I see you" say we no more is heard,
Voices still'd surrender, lay bare
A gentle word...

Fades the laughter passing, as shrouded hope lies bound,
"Hello my friend I see you"...no more
I hear this sound...

Falling tears forever, lay bare a gentle word,
Like a blight o'er spirit, "My friend"
No more is heard...

*Down dropt the breeze, the sails dropt down, "Twas sad as sad could be; And we did speak only to break the silence of the sea!...Samuel Taylor Coleridge*

# Herons on the Breeze

Sunset's simple majesty fading in the sky,
Casting crimson colors, kissing day goodbye...
The moment of this beauty like a canvas bare,
Golden o'er the ocean in silent
Evening's fair...

By cypress scented waters and ancient oak'n trees,
Silhouetted wading, herons on the breeze...
To the moon awaiting sunset's majesty,
Golden in her silence, flowing out
To sea...

Romancing is the sunset, kissing day goodbye,
A lullaby she's singing, fading in the sky...
Sleepy palms and flowers like a canvas bare,
O'er the ocean golden in silent
Evening's bare...

By cypress scented waters and ancient oak'n trees,
Silhouetted wading, herons on
The breeze...

"I love the silent hour of night, for blissful dreams
may then arise...revealing to my charmed sight what
may not bless my waking eyes"...Anne Bronte

"I wish you to know that you have been the last
dream of my soul"...Charles Dickens

# I'll Dream of You Again

Away the day without you fades,
Dimming bluing skies...
Like birds of song in slumber sleep,
In dreams my heart
Denies...

Aside I cast those silent nights,
Till light of day creeps in...
As blush of golden rays surround,
Dreams of you
Again...

Sunlight winks with promise born,
Though my heart in dreams deny...
Like birds of song awake the day,
Away on wings they
Fly...

Unseen hope in dreams may fade,
Till light of day creeps in...
Amid the doubts of nevermore,
I'll dream tonight of
You again...

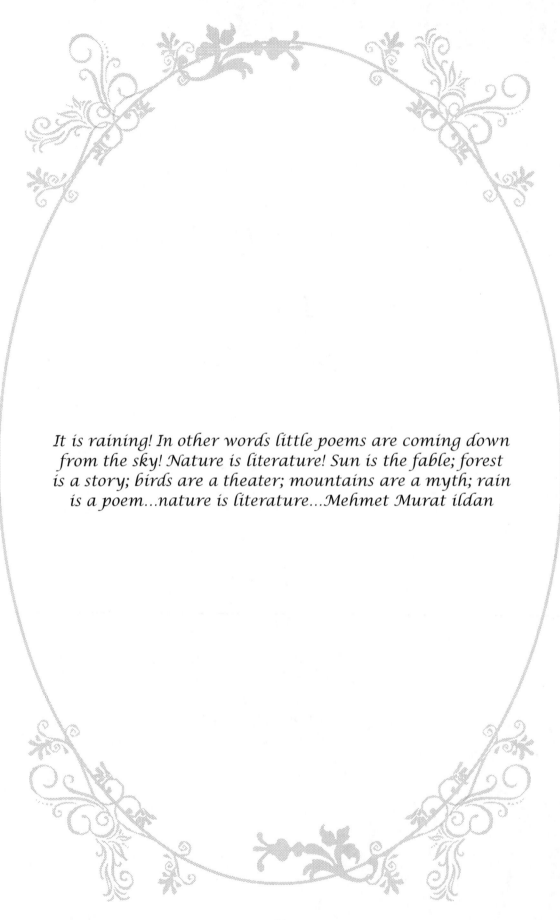

*It is raining! In other words little poems are coming down from the sky! Nature is literature! Sun is the fable; forest is a story; birds are a theater; mountains are a myth; rain is a poem...nature is literature...Mehmet Murat ildan*

# In Cadence Crickets Sing

The eve of twilight wanderings, 'neath skyways purple-gray,
Waking dreaming daylight owls from sleepy yesterday...
'Neath woodlands darkened canopy in cadence crickets sing,
With katydids in chorus, while
Flies of butter wing...

On last of shattered sunbeams speckle softly forest floors,
Where mouse's brown in summer hide their winter's store...
Leaves scattered late from autumn mocking budding trees,
On twilight's scented wanderings in
Fragrant swirling breeze...

Willows sadly weeping with leaves of tender green,
'Neath woodland's darkened canopy where tiny acorns dream...
Humming in the distance their music centuries old,
Bees of honey caroling on beams of
Evening's gold...

In tangled vines on woodland floors crickets nightly sing,
With katydids in chorus while
Flies of butter wing...

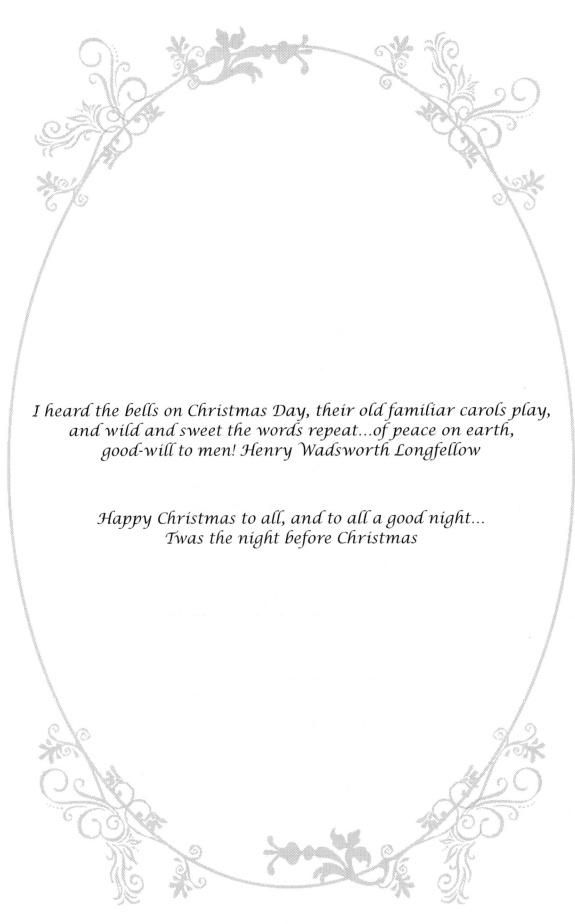

*I heard the bells on Christmas Day, their old familiar carols play,*
*and wild and sweet the words repeat...of peace on earth,*
*good-will to men! Henry Wadsworth Longfellow*

*Happy Christmas to all, and to all a good night...*
*Twas the night before Christmas*

# Merry Christmas my Friends

Silent Night and Holy Night, 'neath shining stars so bright,
Snowy scenes with holly greens, wrapping earth in light...
Country scenes at Christmastime, flakes dancing in the vale,
Church bells sounding merrily, ringing
Through the dale...

Wise Men Three and Christmas trees, of storybooks and lore,
Cones of pine from evergreens, scents a wreathed draped door...
Wrapped gifts of brightest satin, waiting Christmas morn,
Neath trees now decorated as twinkling
Lights adorn...

Cracklin' pine by firelight, shadow Santa in the snow,
Grandfather snoring sleepily, warmed by embers glow...
Country scenes with holly greens, twinklin' red and green,
Draped garland on the mantle, complete this
Christmas scene...

Wise Men Three and Christmas trees, of storybooks and lore,
Cones of pine from evergreens, scent a wreathed draped door...
Silent Night and Holy Night, echoes time before,
Wishing Merry Christmas and...
"Peace forevermore"

*Those who do not weep, do not see...Victor Hugo*

*It's so much darker when a light goes out than it would have been if it has never shone...John Steinbeck*

*(Dedication to all the innocents that have died by gun violence)*

# Nearer My God to Thee...

My soul I wear outside my breast,
With beating heart my spirit rest...
In thought I pause at death's despair,
Remains my anger cold
And bare...

Closed eyes awake in dreamless sleep,
Lips sad in prayer, their souls please keep...
Doorways ajar in darkened night,
Now angels all in heaven's
Light...

Nearer my God to thee,
Away this day no more to see...
Lips sad in prayer of gladness spent,
From hate filled hearts and
Anger sent...

My hands I clasp this darkened eve,
As brightest stars in heaven grieve...
With scornful tears our-selves to blame,
For swords unsheathed is
Mankinds shame...

Nearer my God to thee...
In beauty wings now
Angels free...

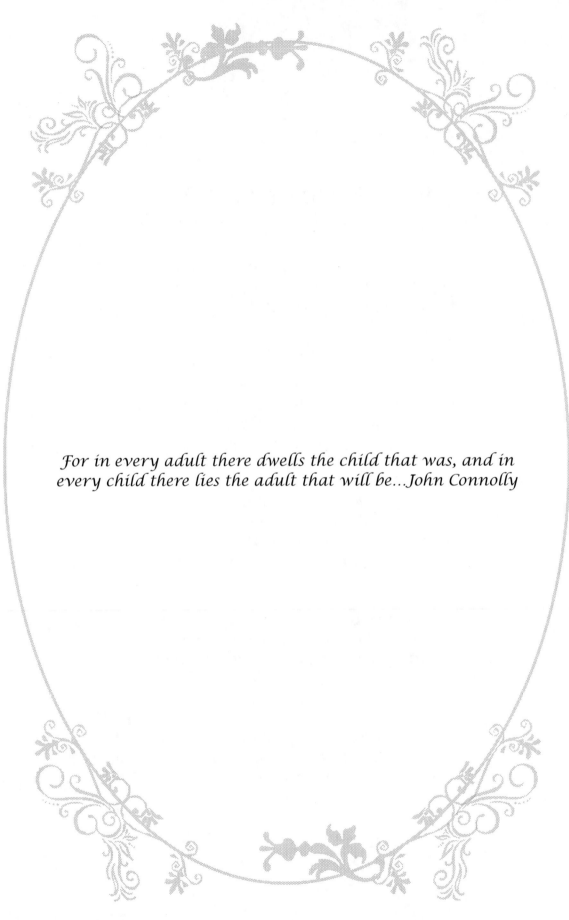

*For in every adult there dwells the child that was, and in
every child there lies the adult that will be...John Connolly*

# Of Bitter Weeds or Laughter

Echoed laughter sweet and fair from pathways overgrown,
Wildflowers fragrant yesterday where happy memories roam...
As embracing breezes whisper from valleys distant dales,
Blowing dreamlike visions where
Childhood often dwells...

In silent place a memory from darken'd shrouded mist,
Of bitter weeds or laughter sweet, overgrown yet kiss'd...
Before me lies my yesterday where childhood always dwells,
As breezes mock my memories, where
Ghostly youth prevails...

Deepened echoes herald thought from many quiet hours,
When scented flowers yesterday oft the dream empowers...
Yesterdays in shadows cling, searching youthful trails,
Of scented pathways overgrown, where
Childhood always dwells...

Ghostlike visions silent stand, in darkn'd shrouded mist,
Of bitter weeds or laughter sweet, overgrown yet kiss'd...
Echoed laughter fair and sweet, waits yet without delay,
Where youthful shadows herald search,
Mocking yesterday...

*We ought to do good to others as simply as a horse runs, or a bee makes honey, or a vine bears grapes season after season without thinking of the grapes it has borne...Marcus Aurelius*

# Of Wisteria & Lavender

Purple fragrant petals on trellis painted white,
Forever scenting summer to bumblebee's delight...
By tiny fairies winging o'er my greening lawn,
Leaving little prints of silver in
Morning's quiet dawn...

Dreary midnight wanders away in pinkish rays,
On shadows of wisteria in morning's early grays...
Her purple fragrant petals, on trellis painted white,
Waves to lavender and violets to
Bumblebees delight...

Budding roses scarlet where flies of butter dance,
By lightly painted lattice as dragonflies romance...
Speckled sunbeams playing over greening lawn,
Shading tiny fairies in morning's
Quiet dawn...

Wisteria and Lavender o'er morning lawn's and lea,
Forever scenting summer to delight'd
Bumblebees...

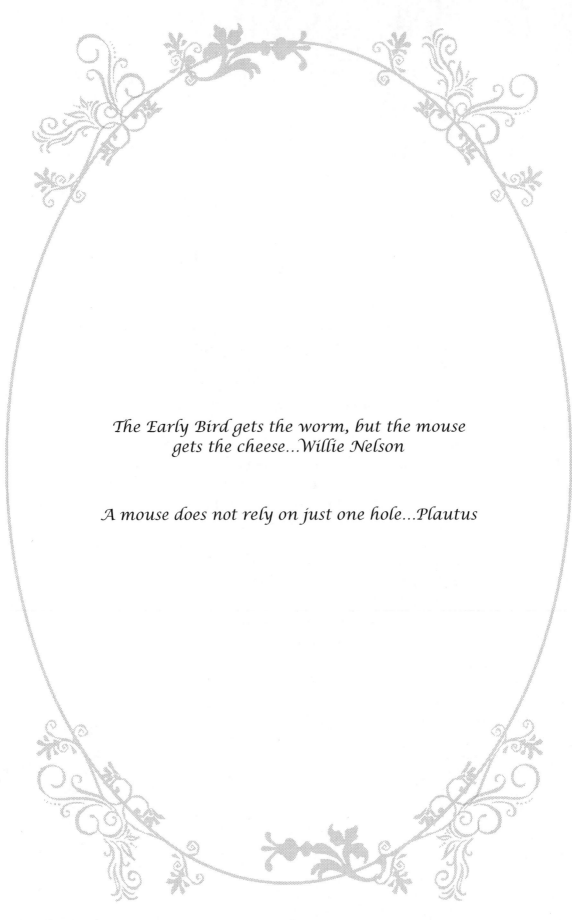

*The Early Bird gets the worm, but the mouse
gets the cheese...Willie Nelson*

*A mouse does not rely on just one hole...Plautus*

# On Attics Stair

Once a mouse at Christmas time,
Ate my cheese and drank my wine...
Twitching whiskers to and fro,
Watching while I sleep
Below...

Arrived with spring again I fear,
A nightly gnawing yet I hear...
Awake I peek within my bed,
Yonder there his
Furry head...

Traps I set without compare,
With cheese I laced on attics stair...
A tiny sneer upon my face,
This trap with cheese
On which I laced...

Asleep tonight with snoring breath,
Dreaming of this mouse's death...
Again awake with slitted eye,
A furry mouse that
Didn't die...

Twitching whiskers left and right,
His eyes aglow throughout the night...
A piece of cheese upon his lips,
In his hand my wine
He sips...

Now he beds on attics stair,
In wedded bliss his
Family there...

*The deep roots never doubt spring will come...Marty Rubin*

*And the spring arose on the garden fair, like the spirit of love felt everywhere; And each flower and herb on Earth's dark breast... rose from the dreams of its wintry rest...Percy Bysshe Shelley*

# On Yonder Hill

Asleep they nod neath winter's cold,
Awaiting spring-times gentle hold...
Swaying not, yet cold and still,
While dreaming dreams on
Yonder hill...

Fair the moon in distant light,
Comforts them asleep this night...
Through valleys snowy quiet dales,
Scenting not their mountain
Vales...

Tender green their leaves shall grow,
Awaiting not the winter's snow...
Un-furling blooms in disarray,
On yonder hill again
To sway...

Peeks the petals and scents the rose,
When spring arrives, the winter goes...
Green their leaves in quiet dales,
Again to scent their mountain
Vales...

*Come away, O human child! To the waters and the wild,
with a faery, hand in hand...for the world's more full
of weeping than you can understand...W.B. Yeats*

*Fairies with gossamer wings, bring forth beauty, grace and joyful
things. Fairies of Earth are caretakers of our soil, water and
trees...they watch over beautiful creatures such as bears, bunnies,
and bees....appreciate the place from which you stand, then trod
carefully each step you make across this land....Molly Friedenfeld*

# Outside My Window

Outside my window watching
Paused fairies in the dew...
Silvered wings of magic,
Shimmered as they
Flew...

Through each shadow nightly,
Bright the moon may be...
Ghost-like wild their spirit,
As fairies flying
Free...

Beneath my window faintly,
Wings fluttered silver-gray...
As a whispered echo,
Whisking me
Away...

Through your window peeking,
While looking right at you...
Ghost-like is my spirit,
Pausing in the
Dew...

Through each shadow nightly.
Bright the moon may be...
With wings of silver'd magic
As a fairy flying
Free...

The moment you doubt whether you can fly, you cease forever to be able to do it...so come with me, where dreams are born, and time is never planned. Just think of happy things, and your heart will fly on wings forever in Never-Never Land...J.M. Barrie (Peter Pan)

# Path to Never-Never Land

Stones of pebbled pathways, through a meadows deep,
Silent streams a'flowing in woodland's yet asleep...
Evening's moon a wonder, haunting summer's eve's,
On doorways path to never-land, 'neath
Ancient oak'n trees...

Enchanted forest fancy, n'er bids the spring adieu,
On boughs of happy oak'n tree where tiny acorns grew...
Pale yellow'd sunshine falters in silence o're the dales,
By winking moon of wonder, hauntin
Summer vales...

Stones of cobbled pathways, echo mystery's never told,
Through sleepy forest meadows embraced in yellow'd gold...
On doorways path to never-land, 'neath ancient oak'n trees,
Fairies wing in silence, on haunted
Summer's eves...

On doorways path to never-land where tiny acorns grew,
Enchanted forest fancy, n'er bids the
Spring adieu...

*Beautiful as a dandelion blossom, golden in the green grass. This life can be. Common as a dandelion blossom, beautiful in the clean grass, not beautiful because common, beautiful because beautiful... noble because common, because free...Edna St. Vincent Millay*

# Peeping Buds of Yellow

Peeping buds of yellow in meadows green and gay,
In sunshine's early promise chasing night away...
Springtime saunters gaily in colored disarray,
Watching bees of bumble a'waiting
Summer's day...

In summer's early promise, chasing spring away,
Winter's wind forgotten in meadows green and gay...
Daffodils and crocus nod with sleepy heads,
As buds of peeping yellow surround
Their garden's bed...

Winter's silent chorus stirs in woodland's deep,
Singing songs in cadence awake from winter's sleep...
As springtime gaily saunters in colored disarray,
Those peeping buds of yellow chase
Wintertime away...

Laughing dandelions in grasses green'd and bright,
O'er meadows gowned in clover where
Bees of bumble lite...

*...and then, I have nature and art and poetry, and if that'd not enough, what is enough? Vincent Van Gogh*

# Renoir Painted Autumn...

Renoir painted autumn, Shakespeare wrote of love,
When orange, gold and yellow, tint the trees above...
Leaves once green'd now falling, softly on the ground,
As winter waits in hiding, blowing
Winds around...

Still summer flaunts her beauty, warming fall-like days,
Where butterflies and robins, seek her scented rays...
Floor of forest littered, with brightly fallen leaves,
While in a sunset twirling, with
Summer's final breeze...

Above great geese are flying, o'er a woodland's canopy,
When orange, gold and yellow, tint the forest tree...
Fragrant winds bring promise, as winter tyme creeps by,
For Mother Earth is yawning, watching
Autumn's sky...

Yes, Renoir painted autumn, and Shakespeare wrote of love,
As earth's Poet and Creator tints His
Sky above...

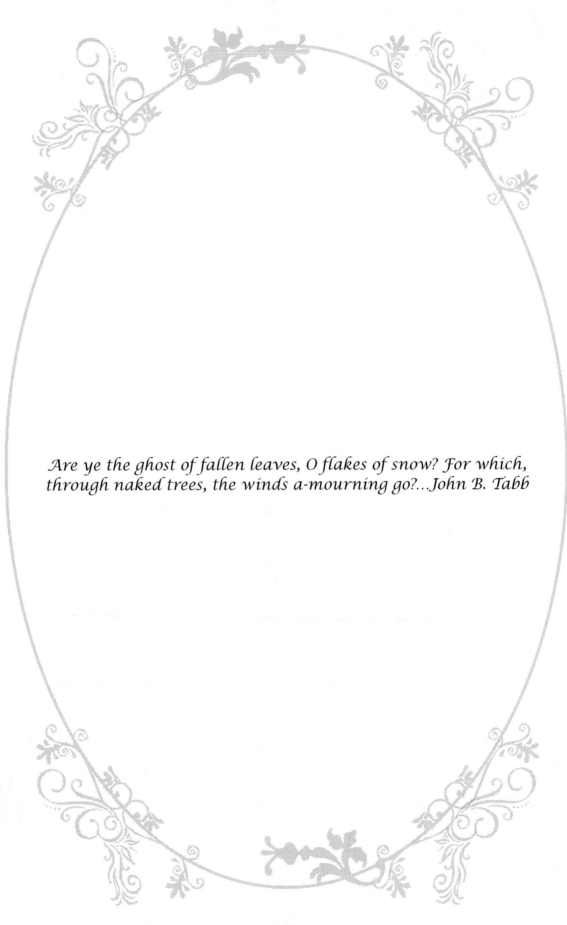

*Are ye the ghost of fallen leaves, O flakes of snow? For which, through naked trees, the winds a-mourning go?...John B. Tabb*

# Rods with Golden Glow

Down the valley's meadow quietly arrayed,
Pale petunias purple sadly disarrayed...
Forget-me-nots in forest shudder in the breeze,
As violets shrink in mornings, 'neath
Autumns falling leaves...

Growling tiger-lilies weep at coming snows,
As wilderness still beckons, rods with golden glow...
Roses prim of maiden, sleeps the cold away,
While waking mountain daisy whose
Fragrance yet will stay...

Lavender with dewdrops mourns the summer eve,
Whose tiny fragile petals, fragrants dawnings breeze...
As adoring beams of yellow caress with golden glow,
Embracing dying flowers in summers
Farewell show...

Away the flowers fragrant scent not the winters snow,
For wilderness still beckons those
Rods with golden glow...

*Winter is an etching, spring a watercolor, summer an oil painting and autumn a mosaic of them all...Stanley Horowitz.*

# Scattered Leaves of Autumn

Gowned in colored umber-red in a forest gold,
Nodding flowers seeking sleep vanish from the cold...
In light of mellow'd evenings summer yet denies,
Scattered leaves on woodland's floor
Hide the butterflies...

Fragrant breeze on cattails blow by a flowing stream,
As willows bow in silence, weep to evergreens...
Rods of golden yellow scent the autumns breeze,
Twirling leaves of umber-red 'neath their
Oak'n trees...

Bob-o-links and rabbits white sleep in thickets deep,
Birchen trees and evergreens nods as willows weep...
Honeybees and crickets pause in autumns hush,
Waiting winters grayness till springtime's
Greening blush...

In light of mellow'd evening summer yet denies,
Scattered leaves on woodland's floor
Hide yet the butterfies...

*If winter is slumber and spring is birth, and summer is life, then autumn rounds out to be reflection. It's a time of year when the leaves are down and the harvest is in and the perennials are gone...Mother Earth just closed up the drapes on another year and it's time to refect on what's come before...Mitchell Burgess*

# Somewhere Lies the Autumn

Out from summer, autumn lies,
As mid-September yet denies...
Sips the bees from nectar sweet...
As pumpkins fat in,
Gardens weep...

Southbound geese in skyways fly,
O'er gardens green'd in summers die...
As butter'flies to Mexico,
Where winter snowflakes
Never go...

Pines of cones from evergreens,
Fall in woodlands quite unseen...
O'er falling leaves from oaken trees,
Once summers home to
Bumble-bees...

Squirrels gray tailed in forest deep,
Storing nuts for winters sleep...
Sad mouse's brown to autumn sigh,
As gardens green'd in
Summers die...

Sips the bees from nectar sweet,
As pumpkins fat in ...
Gardens weep...

*And my heart springs anew. Bright and confident and true...and the old love comes to meet me, in the dawning and the dew...Robert Louis Stevenson*

# Sunbeams, Fairies & Specters

With sunbeams spun like honey after darkest night,
The dawning shadows fairies winged with golden light...
Gently melts nights specters as twilight bids adieu,
As winged fairies footprints sparkle
In softest morning's dew...

Yawning violets waking, flirt with roses red,
While nudging daisies yellow outside their gardens bed...
Sunbeams spun like honey, dance on silver'd streams,
Where winking stars in hiding, again
Return to dream...

Weeps the twilight sadly, each wakeful morning born,
In dawning's whispered promise, fairies gold adorn...
As specters dream in silence, shrouded till twilight,
Waiting darkest shadows, again
In ghostly night...

Fairies winged and golden, wait yet for morning's dew.
As sunbeams spun like honey, again bids night adieu...
Where winking stars in hiding, again return to dream,
While peering through the shadows,
O'er honey colored beams...

*And the spring arose on the garden fair, like the spring of love felt everywhere; And each flower and herb on Earth's dark breast rose from the dreams of its wintry rest...Percy Bysshe Shelley*

*The sun just touched the morning; the morning happy thing. Supposed that he had come to dwell and life would be all spring...Emily Dickinson*

# "Springtime In Between"

Birds I hear a'chirping on limbs with buds unseen,
Winds tremble yet the willows with winter in-between...
Lying low sweet valleys, fields cry out their woe,
Waiting blue bells fragrance where
Flowers wildly grow...

Woodlands weeping sadly wishing springtime days,
When sunshine's morning colors whisk away the grays...
Far away the roses to fragrant yet the skies,
Whose petals red stay sleeping in valley's
Sweet disguise...

These days of fated winter doomed with buds unseen,
Betrayed by flowers sleeping and springtime in-between...
Lying low sweet valleys fragrant yet the vale,
As awake the petals sleeping scent again
The dale...

Woodland breezes beckon modest flowers red,
Enticing roses fragrant out from winter's bed...
On limbs with buds a bloomin' without a bit of woe,
With winter in the offing again sweet
Flowers grow...

*The sun just touched the morning, the morning, happy thing. Supposed that he had come to dwell, and life would be all spring...Emily Dickinson*

# Springtime in the Mountains

It's springtime in the mountains,
With just a hint of snow...
Where simple spirits of the land,
Let tiny bluebells
Grow...

Timeless winter days now gone,
As springtime settles in...
With greening of the woodlands,
From mountains meadow
Glen...

The silence of creation,
Reveals herself each spring...
Its there she forms her chorus,
When all her creatures
Sing...

White snowcaps on the mountains,
Each morning newly glisten...
When springtime makes a promise,
Her spirits pause
To listen...

"I send to you this promise,
Of mornings bright and clear...
Of silent music everywhere,
That you alone shall
Hear..."

The magic o'er the mountains
On dawning's quiet morn...
Is nature's gentle spirit,
Watching springtime
Newly born...

When all my days are ending and I have no songs to sing, I think that I shall not be too old to stare at everything. As I stared once at a nursery door or a tall tree and a swing...G.K. Chesterton

Sunsets like childhood are viewed with wonder, not just because they are beautiful but because they are fleeting...Richard Paul Evans

# Steps Once Blue

On wooden steps once painted blue, a memory there of me with you,
A fancied flight in days of old, of songs composed
For hearts to hold...

The summer's sun on wrinkled brow
where I yet sit in here and now,
Upon the porch a patch of blue, of days long gone
I once knew...

Roses red 'neath willows roam by this old house once my home,
Still'd by time this mountain vale, remembers yet
My youthful tale...

From squinting eyes my falling tears
recalling you those many years,
O'er the bridge and down the lane, lilacs grow
Still the same...

As shadows fall on steps once blue, of days long gone
I once knew...

*If there is a heaven, it's certain our animals are to be there. Their lives become so entangled in our own, it would take more than an archangel to detangle them...Pam Brown*

# Sweet Prince Goodnight

Sweet Prince goodnight, in dreams forever nigh,
Sleep now Sweet Prince, as wanderer of sky...
Echoed barks of yesterday, vainly I shall borrow,
Fading not your essence of memories
Through the morrow...

Evermore remembering our laughter all the years,
Giving love unspoken, stronger through my tears...
Bonds unbroken always, as wanderer of sky,
Not just my friend, but soul mate in
Dreams forever nigh...

Starlight beckons sadly, as angels call you home,
In heavens speckled tapestry, forever now to roam...
With echoed barks of yesterday, in dreams forever nigh,
Sleep now Sweet Prince, my soul mate,
As wanderer of sky...

Bell-towers striking one o'clock, as angels call'd you home,
In heavens speckled tapestry, forever
Now you roam...

(Dedicated to Winston Goss, joining the angels at 1pm, July 27, 2017)

*There is, one knows not what sweet mystery about this sea, whose gently awful stirrings speak of some hidden soul beneath...Herman Melville*

# Swimming with Mermaids

Waking from my dream-state,
In my bed, soft feathers white...
With the mermaids swimming,
On dolphins in
Delight...

Beneath the foamy waters,
By diamond studded shores...
With the mermaids swimming,
Behind my bedroom
Doors...

Scales of tinted turquoise,
On dolphins as they ride...
Swimming with the mermaids
Each night by oceans
Tide...

Whispers from my dream-state,
As the mermaids beckon me...
With my scales of turquoise,
Swimming out to
Sea...

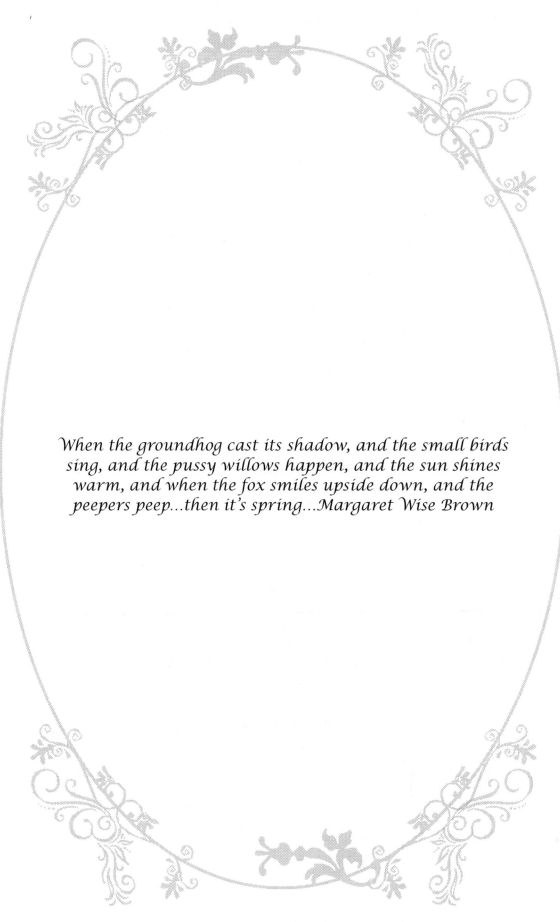

When the groundhog cast its shadow, and the small birds sing, and the pussy willows happen, and the sun shines warm, and when the fox smiles upside down, and the peepers peep...then it's spring...Margaret Wise Brown

# The Fox in Spring

Through grassy meadows wild and bare,
Springtime scents the fox's lair...
As bells of blue in faint disguise,
Wave to winter, their
Goodbyes...

Where mountains shade their forest friends,
With rivers flowing round the bend...
As doves of mourning softly gray,
Watch fox's kits in daylight
Play...

Now, nature wakes this springtime scene,
To woodlands barely turning green...
As bells of blue in faint disguise,
Wave to winter, their\
Goodbyes...

As black eyes peer inside their lair,
In grassy meadows, wild and bare...
'Neath mountains cap'd in winters snow,
Where bells of blue in springtime
Grow...

As doves of mourning softly gray,
Watch fox's kits in daylight
Play...

*May my faith always be at the end of day, like a hummingbird ...returning to its favorite flower...Sanober Khan*

# The Hummingbird

Yonder flies a hummingbird waiting evening's hour,
Flaunting wings of crimson red from flower to flower...
Upward springing, purpl'd breast, on stems of slender green,
By modest weeds unnamed or known,
In woodlands seldom seen...

In evenings quiet sonnet, 'neath skyways turquoise-blue,
By forests fragrant bodice in twilight's early dew...
As yonder flies a hummingbird in woodlands seldom seen,
Upward springing, purpl'd breast, on
Stems of slender green...

Curtains close on western skies while bidding day adieu,
As yonder flies a hummingbird 'neath skyways turquoise-blue...
In evenings quiet sonnet waiting evening's hour,
Flaunting wings of crimson red
From flower to flower...

While humble flowers in disguise sleep in woodland's bed,
Yonder flies a hummingbird with
Wings of crimson-red...

*I am not what you are, I am only what I can see...I am me...Debasish Mridha*

# The Mermaids

By the shore at midnight, singing to the moon,
She heard a mermaid humming a song
Without a tune...

She saw the mermaid beckon pointing in the air,
While slipping 'neath the water, to me
I thought she dared...

Beneath the water smiling away from shores of land,
Laughing with the mermaid now swimming
Hand in hand...

The moonlight shone as diamonds, crashing waves to shore,
While barely feeling bottom, on the slippery
Ocean floor...

Again the mermaid humming a song without a tune,
Not swimming now the mermaid, as she lay
Now on the dune...

As I swam beneath the water from ocean's sandy shore,
I heard the mermaid laughing like she never
Laughed before...

As dawn was breaking softly glancing back towards sea,
The mermaid that was laughing...was just
The other...
Me...

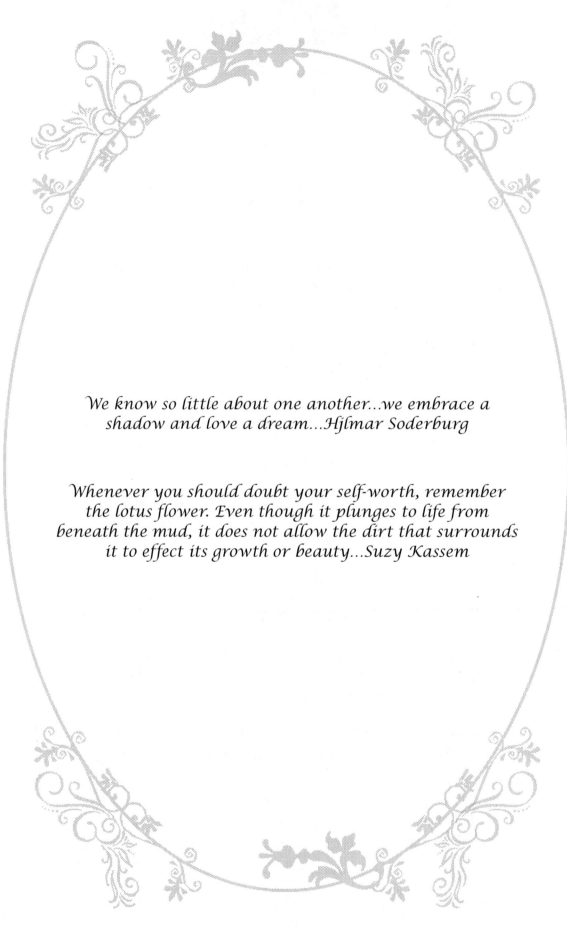

We know so little about one another...we embrace a
shadow and love a dream...Hjlmar Soderburg

Whenever you should doubt your self-worth, remember
the lotus flower. Even though it plunges to life from
beneath the mud, it does not allow the dirt that surrounds
it to effect its growth or beauty...Suzy Kassem

# The Quarreling Humble Bumble

There among the cattails fairies tiny go,
Evening's dewy spirit, wing'd a golden glow...
Under skyways singing frogs in shady light,
Still'd on pads of lilies as fading
Is the night...

Laurels scented waving whisper silently,
"Beware ye fairies tiny suspecting not the bee"...
For nector covered bumbles bold,
Envy fairies winged
Of gold...

Dream on fairies tiny wings a golden glow,
Suspecting not the bumble never friend but foe...
With a sparrow flying or frogs in shady light,
Yourself please be forever in
Evening's dewy night...

Quarreling humble bumbles... bees of jealousy,
A fairy never tiny, just a
Bumblebee is
He...

*Though these words will never find you, I hope you know I was thinking about you today...and that I was wishing you every happiness...love always...the one you loved once...Ranata Suzuki*

# The Letter

Written of hand, each letter each word,
Beautifully penned, lovingly heard...
In silence your voice carried by air,
Echo's to me...everywhere...

Forever an ever this moment is mine,
Reading your thoughts, forgotten in time...
Thinned paper with prose written to me,
Tomorrow unspoken...
Never to be...

Small seasonal stamp attached with a smile,
On envelope worn in loving denial...
In silence your voice echo's to me,
Lost to the winds...
Never to be...

Written of hand, each letter each word,
Of long ago times, forever unheard...
Sealed with a kiss, forgotten in time,
Forever and ever this moment
Is mine...

Away your words fade this letter of old,
Though crumpled with age I carefully fold...
In silence your voice still echo's to me,
Lost to the winds...
Never to be...

*When you wake up with a song stuck in your head, it means an angel sang you to sleep...Denise Baer*

*When angels visit us, we do not hear the rustle of wings, nor feel the feathery touch of the breast of a dove; but we know their presence by the love they create in our hearts...Mary Baker Eddy*

# Waking Not the Flowers

Dark of night in dawning's fade,
O'er shadows dwelling hours...
As quiet dancing breezes blow,
Waking not the
Flowers...

In silhouette my hand I reach,
Touching darkest air...
Near my ears a whisper heard,
From angels winged
And fair...

Their symphony of echoed song,
In shadows dwelling hours...
With skin of dew in dawning's fade,
Waking not the
Flowers...

Asleep my ears a whisper heard,
Angels winged and fair...
Demands the heart of mortal man,
Who touches darkest
Air...

Still'd the angels winged and fair,
In shadows dwelling hours...
Come they to you with whisper heard,
Waking not the
Flowers...

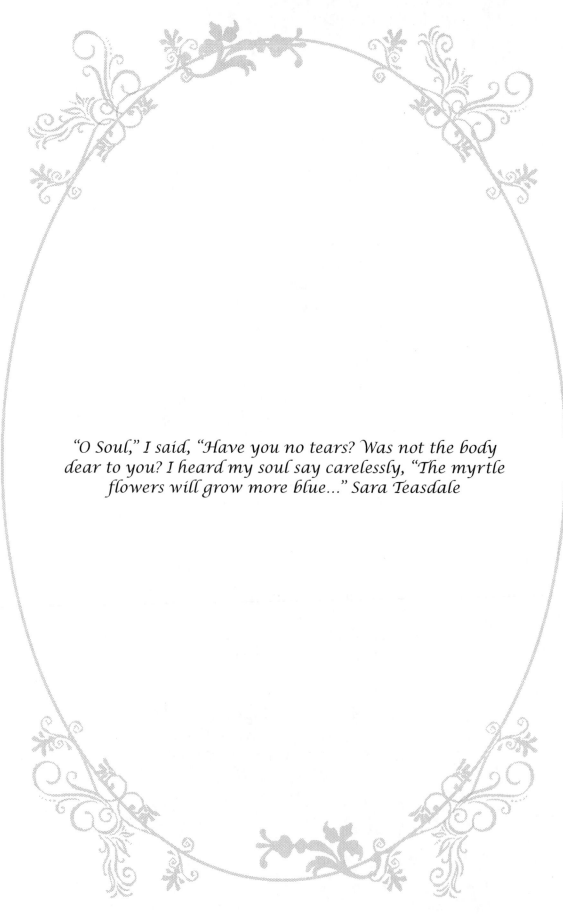

"O Soul," I said, "Have you no tears? Was not the body dear to you? I heard my soul say carelessly, "The myrtle flowers will grow more blue..." Sara Teasdale

# When Flower's Die

I see God in a flower,
Each sunrise or twilight hour...
In country green, or tropic glade,
Among the trees, or
Quiet shade...

As scented winds in summer's sky,
Away on wings His angels fly...
Kissing earth each dawning morn,
As flowers die, another's
Born...

Fade the rose with petals red,
In winters cold and snowy bed...
Away on wings His angels fly,
Yet God is there, when
Flowers die...

Sunrise mourns each passing night,
While kissing earth with yellow'd light...
Away on wings His angels cry,
Yet God is there when
Twilight dies...

Each passing night His voice I hear,
Holding calm each flower near...
Away on wings His angels fly,
Yet God is there when
Flowers die...

*Tis the night - the night of the graves delight, and the warlocks
are at their play; Ye think that without, the wild wind shout,
but no, it is they - it is they! Arthur Cleveland Coxe*

# When Goblins Dance & Witches Fly

As specters stir 'neath yellow'd leaves,
While waiting frosty autumn eves...
"Forevermore" the ravens cry,
When goblins dance and
Witches fly...

'Neath woodlands yellow autumns deep,
Awake the specters from their sleep...
Ghostlike visions nothing more,
Shadow cluttered forest
Floor...

Spooky tombstones speak the dead,
Where specters rest their weary heads...
As little children scream and shout,
Watching goblins rush
About,

Pumpkins shine each hallowed eve,
As children laugh and specters grieve...
"Forevermore" the ravens cry,
When goblins dance and
Witches fly...

As specters dressed in fairy lands...
Their candy clutched in tiny hands,
Where goblins sleep in little beds,
With ghostlike visions in
Their heads...

*April's air stirs in Willow-leaves...as a butterfly
floats and balances...Matsuo Basho*

*And the spring arose on the garden fair. Like
the spirit of love felt everywhere;
And each flower and herb on Earth's dark breast, rose from
the dreams of its wintry rest...Percy Bysshe Shelley*

# When Not the Willows Weep

Frogs in chorus singing in bogs on logs unseen,
Away the winter's fleeing, in meadows
Barely green...

Williams sweet now fragrant nudging roses red,
Scenting breezes blowing around
Their garden's bed...

No longer are they weeping, ancient willows green,
In the sunlight dancing as frogs
In chorus sing...

Blooming yet the daisies where bright fly butterflies,
Enchanting mountain meadows
Wearing springs disguise...

Singing songs of spring-time, when willows not they weep,
But in the sunlight dancing, as awake the
Frogs from sleep...

Williams sweet now fragrant beckon butterflies,
As away the winter's fleeing now
Wearing springs
Disguise...

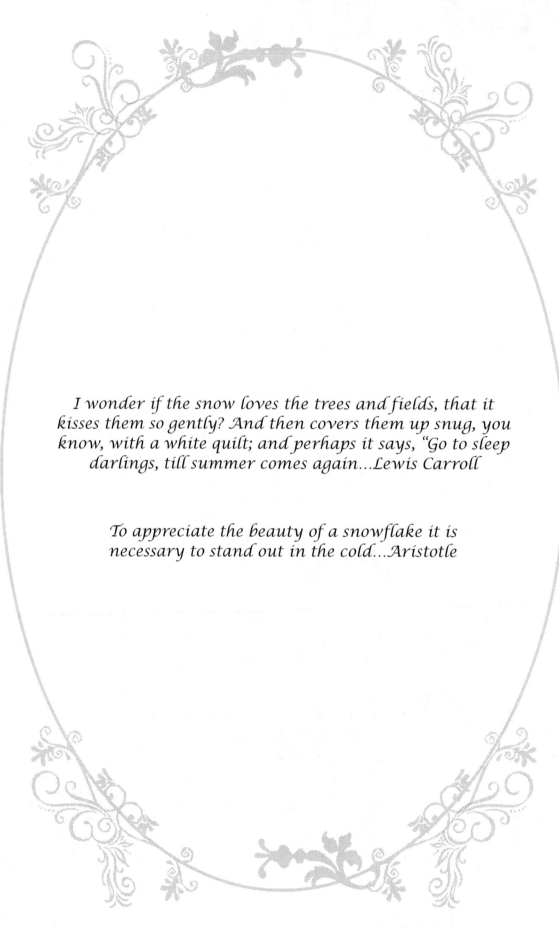

*I wonder if the snow loves the trees and fields, that it kisses them so gently? And then covers them up snug, you know, with a white quilt; and perhaps it says, "Go to sleep darlings, till summer comes again...Lewis Carroll*

*To appreciate the beauty of a snowflake it is necessary to stand out in the cold...Aristotle*

# Wings of Winter

Beneath a spreading evergreen,
While scenting woods and lea...
Flakes of snow in silence fall,
In merriment and
Glee...

Dancing, twirling whitely,
Together through the air...
Kissing cones of evergreen,
In woods and meadows
Bare...

Asleep the rose in summer past,
Once scenting woods and lea...
As flakes of snow in silence fall,
In merriment and
Glee...

Winds of winter blowing through,
Frosting all the air...
As flakes of snow in silence fall,
In woods and meadows
Bare...

Asleep the lands in winter deep,
While nods the bumblebee...
As flakes of snow in silence fall,
In merriment and
Glee...

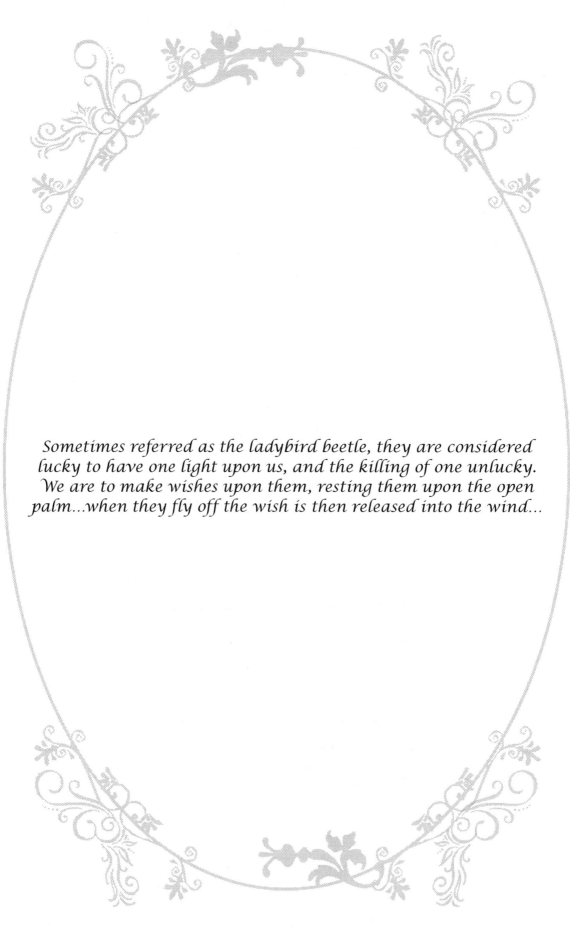

Sometimes referred as the ladybird beetle, they are considered lucky to have one light upon us, and the killing of one unlucky. We are to make wishes upon them, resting them upon the open palm...when they fly off the wish is then released into the wind...

# With Crimson-Colored Spotted Wings

In groves of scented myrtle by fragrant winds that blow,
Wandering flies of dragon by streams that ever flow...
As daisies, black and yellow brighten gloomy glades,
With crimson colored spotted wings,
A flying lady in the shade...

O'er meadows greening glory in secret twilight's hour,
As beams of kissing sunlight shelter sleepy flowers...
Daisies black and yellow welcome coming night,
There in the shade a lady, on evening's
Fading light...

Western skyways purple'd while flaunting daylight's blue,
There in the shade a lady where tiny wishes grew...
Her crimson-colored spotted wings flutter as she flies,
Away to home she saunters on
Evening's fading skies...

With crimson-colored spotted wings, a lady in the shade,
There...into the wind releasing hopes
And wishes made...

The glory of friendship is not the outstretched hand,
not the kindly smile, nor the joy of companionship. It
is the spiritual inspiration that comes to you when you
discover that someone else believes in you and is willing
to trust you with a friendship...Ralph Waldo Emerson

What is a friend? A single soul dwelling in two bodies...Aristotle

# Without You

Without you I cannot see,
Or be the person I need to be...
Laughs no longer fill the air,
Without you my life
To share...

Birds of song no more they sing,
O'er graying skies when they wing...
Scented rose no fragrance there,
Without you my life
To share...

Your smiles of friendly innocence,
Reminds my heart of goodness spent...
In winter days and summer's fair,
Without you my life
To share...

No bounds of time that age denies,
Steals not the light in your eyes...
Memories less shall not impair,
Without you my life
To share...

Again I smile recalling when,
Long ago my dearest friend...
No longer shall I despair,
Always there my life
You shared...

*There is a pleasure in the pathless woods, there is rapture in the lonely shore, there is society where none intrudes, by the deep sea, and music in its roar; I love Man not the less, but nature more...Lord Byron*

# Woodland's Chapel

I worship yet in nature's shrine, unto His woodlands
No less divine...
Listen! As the brooding sea, away she washes
Humanity...

I worship yet in nature's shrine, unto His meadows
No less divine...
Listen! As the flowers grow or sleep content in
Winter's snow...

I worship yet in nature's shrine, unto His prairies
No less divine...
Listen! To the eagles song into His heavens
They belong...

I worship yet in nature's shrine, unto His mornings
No less divine...
Listen! As the sunbeams glow sending hope to
Earth below...

O' blessed bird in nature's shrine, unto your message,
So divine...
Listen! To the song he sings, wordless tunes from
God he brings...

Bowing heads in morning's blue, I worship not in
Mortal's pew...
God be praised in nature's shrine,
In woodland's chapel,
No less...divine...